PHOTO OOPS

photographic opportunities gone awry

revised and updated

🔘 HAL BUELL

Black Dog & Leventhal
Paperbacks

Library of Congress Cataloging-in-Publication Data on file
at the offices of Black Dog & Leventhal.

ISBN: 1-57912-377-5

Manufactured in the United States

j i h g f e d c b

Published by
Black Dog & Leventhal Publishers Inc.
151 West 19th Street
New York, NY 10011

Distributed by
Workman Publishing Company
708 Broadway
New York, NY 10003

Dedication

Presidential pets play a significant role in the chronicles of Photo Oops. Because all American presidents have had pets, a thread of history connects them, with each pet somehow defining his owner/head of state. Unlike many people surrounding the Commander-in-Chief, pets are loyal, keep family secrets and offer their masters solace under the most trying circumstances.

Pets have their own opinions about the issues of our time. They can—and do—get stubborn and refuse to obey their masters, leading observers to wonder whether a man who cannot control his pet can control his cabinet.

A pet can—and will—wiggle out of its master's hands and fall to the ground, giving millions of animal lovers the perception that the master does not know how to care for an animal.

Though they never reveal secrets, pets often approach the media in a friendly and familiar manner that can create doubts among the President's staff. Who really knows what goes on in those pet-media encounters? Are tidbits of information and Tender Vittles being exchanged?

Still, in the long run, pets survive through it all—the media; strange directions from their masters; bumpy, noisy helicopter rides; Air Force One trips *sans* fire hydrants and other irritations.

In appreciation of his contribution to this book, in consideration of his family values image and his role as the nation's First Pet we dedicate this book to Barney, Scottish Terrier *extraordinaire* and the President's constant and reliable companion.

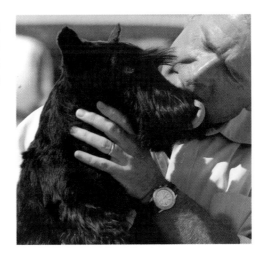

PHOTO OOPS

Photo Ops, aka photo opportunities, are a staple of political management. Photo Oops, on the other hand, are photo ops gone awry. *Photo Oops* throws a new light on politics. An explanation is required.

A photo op is offered to the media by the manager of a politician or a political campaign. The media is advised to be here or be there and to bring their cameras. The campaign manager hopes that a picture of a favored politician doing something picture-worthy will advance the campaign and move him or her closer to elected public office. Campaign managers are crafty and manipulative but even the most devious can sometimes arrange a photo op that becomes a photo oops. As TV news anchorman Dan Rather observed, "The camera never blinks." It will capture the good with the bad, or the bad with the good, as the case may be.

The photo op can be classified. In the interests of a better educated electorate we have tried to include examples of the following categories:

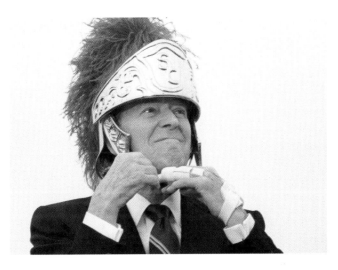

cians choose children's toys—REAL children's toys. Politician have never provided an explanation for this challenge of tradition but ample evidence exists to support its truth. The inescapable conclusion is that politicians must be happier reliving the simple joys of childhood than indulging in the more sophisticated fun seeking of most adults.

Boys And Their Toys

There is a popular ditty that goes like this:

> The difference between
> men and boys,
> Is the price
> of their toys.

That is true of actors and sports figures, tycoons and entrepreneurs, and those in arts and letters. Politicians, however, are different. They do not adhere to this ancient philosophy. When they play with toys, politi-

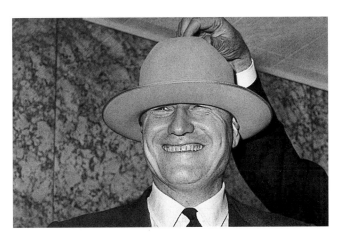

Campaign managers believe toys go over well with voters—things like toy airplanes, yo-yos, rubber alligators, a jack-in-the-box. Politicians love them all because every toy—every child's toy—brings a new delight into the life of the campaigner.

When receiving such a gift, the politician will proudly display it for all to see. There is no shy reluctance for the adult office-seeker to accept such gifts or to conceal his or her liking for children's toys. Every day is Christmas to the accomplished politico.

Politicians and Babies

Politicians are drawn to babies with the inbred instinct of a salmon heading home. It has been that way always. Why politicians act this way remains a mystery, because babies more often cry than coo when cuddled by a politician. And the responsible voter has to ask: Would an intelligent adult hold a strange child more likely to throw up mashed peas and carrots than smile?

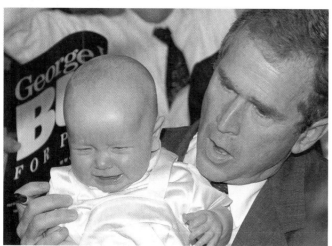

Consider further: Babies are cute whether they coo, scream, cry or throw up. In comparison the politician

is not! Why get into a cute contest?

Any actor with more than an hour of experience says that children upstage the adult performer. The wise thespian avoids acting with them.

Still, day after day, politicians seek the company of children in their bid for votes. But why? The kid can't vote, the parents are interested in getting a picture of their child with the politician in the paper (another mystery) and those who see the picture wonder why the politician isn't talking to people who can reduce the national debt. It's a losing proposition from the start.

But politicians and babies remain inevitably linked. Like bread and butter, like cup and saucer, like Frick and Frack, they have been together throughout history.

The Political Handshake

The political handshake is instinctive to politicians.

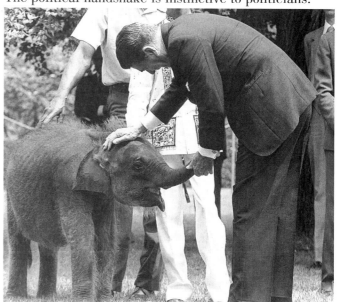

The handshake starts deep in the belly of the office seeker, ignited by the sight of any nearby hand otherwise unoccupied.

This handshake will, in practice, grip the hand of man, woman, child or infant. It will also reach out to the extended paw of a dog or the trunk of an elephant or any appendage that resembles a hand. Despite pain from repeated handshakes, the instinctive process ignites itself repeatedly in a meaningless flurry. There is no pain barrier to the experienced politician faced with handshake potential.

In popular parlance this is called pressing the flesh though that is a misnomer. Frequently the handshake is reduced to barely a touch; there are so many hands to shake but so little time.

Politicians and Critters

Next to babies, the politician's greatest attraction is for critters and other, larger, four-legged beasts, preferably but not exclusively of the barnyard variety.

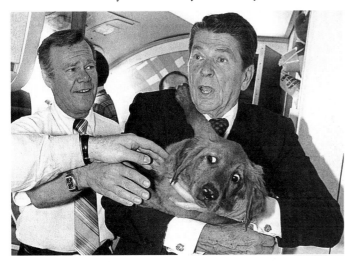

If the critter is small, politicians hold them, cuddle them and treat them much like babies. If the critter is large, politicians ride them, herd them and shake their paws, trunks, hooves, etc.

Pundits may say that a connection with critters will show the politician to be a good guy, salt of the earth, regular fellow. Farmers, however, will tell you that you do not cuddle baby pigs. They may pee on your vest and that would be embarrassing. Baby pigs are meant to be fattened and sent to market, not cuddled like a pet cat.

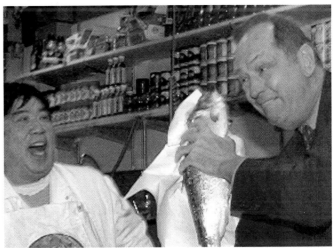

Politicians like to be photographed with dogs. This is more reasonable, for who dares to deny that a dog is man's best friend. Just about every president has had a dog, a few of which have been involved in national controversy. The dogs always won, which is more than can be said for the politicians. It is understandable that politicians would want to be seen with proven winners. Still, dogs and pigs together could not carry the third ward in Chicago.

Politicians and Other People's Clothes

Most politicians possess formidable wardrobes, but that does not prevent them from wearing clothes meant for other people

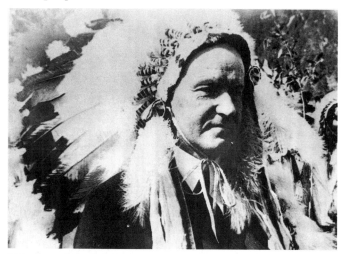

Why a politician dresses in drag opens a line of discussion that would delight Sigmund Freud. The explanation, however, is best not included in the exposé offered in this volume. This is, after all, a family book meant to educate, not titillate.

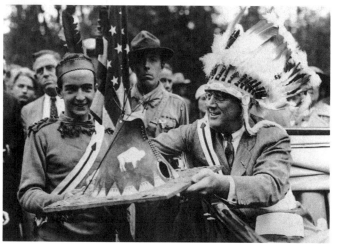

Image makers are people who politicians hire to change their appearance. Image makers are paid fantastic salaries to guide the office seeker's proper selection of wardrobe. The image maker creates a model that promises to inspire voters to pull the right lever on election day. Once decided, however, the politician discards the costume so carefully designed and opts for a cook's apron, the studded leather jacket of a Hell's Angel or military garb of the kind used by Navy SEALS or Green Berets.

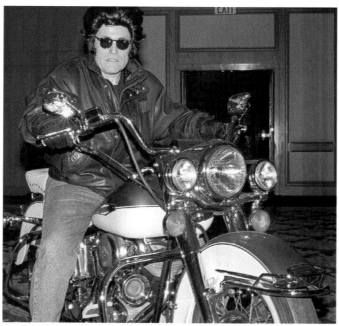

We are told that clothes make the man. If true (and who would doubt the wisdom of the ages) the politician's fashion taste resembles a kind of crazy quilt, patched here with a print, there with a plaid, and over there with an old sheet worn in the center but usable on the edges. Whatever costume works is the one used, but would you cast your ballot for a person who one day is a deli sandwich maker and the next a Bhutanese archer?

The Political Gesture

It is a cliché, but there is no other way to say it: Politicians love to point with pride. The grand political gesture is the political orator's flesh and blood punctuation mark.

They point this way and that, up and down, to the right and to the left.

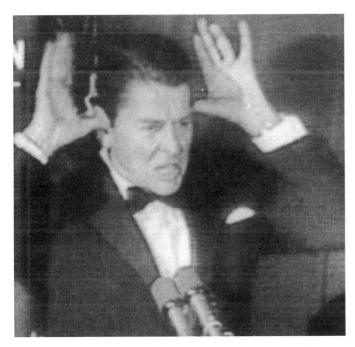

More attention goes into the thrust of their arms than into the words they choose.

Their gestures sweep across the podium the way the great plains sweep across the midland. Politicians believe that a well-timed gesture can explain the intricacies of a complex issue even though the gesture frequently distracts the listener. Perhaps that is its purpose.

Politicians also believe that gestures tell the audience that the politicians comments come from the depths of the heart. The gesture confirms that his message is for YOU, and YOU alone.

Not all gestures are so forceful, of course, and some miss the target.

But no gesture was ever as direct, as unmistakable in its meaning, or as clear in its message as Nelson Rockefeller's Binghamton, NY, sign to the multitude. Now there was a man who knew what he wanted to say.

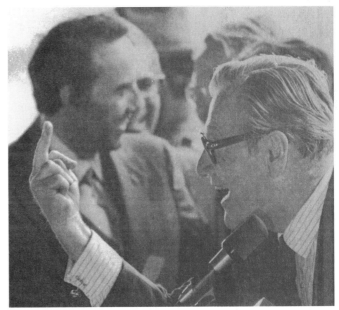

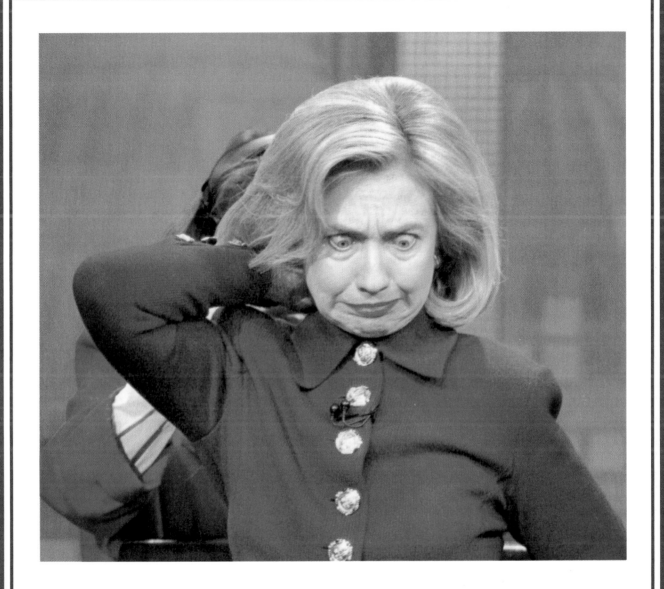

To win an election it sometimes helps to be a contortionist.

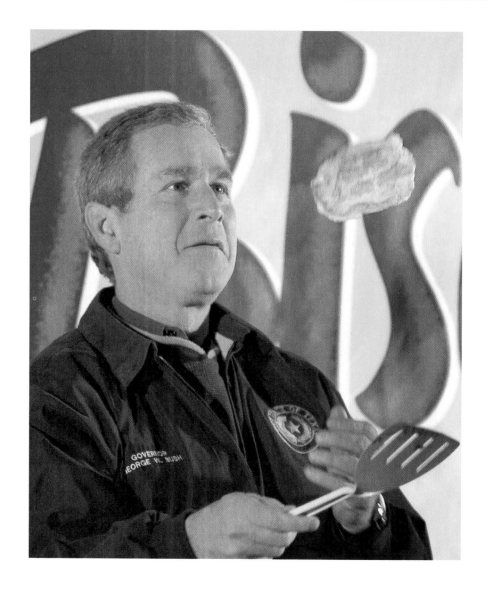

"Heads we invade North Korea, tails we go to Syria."

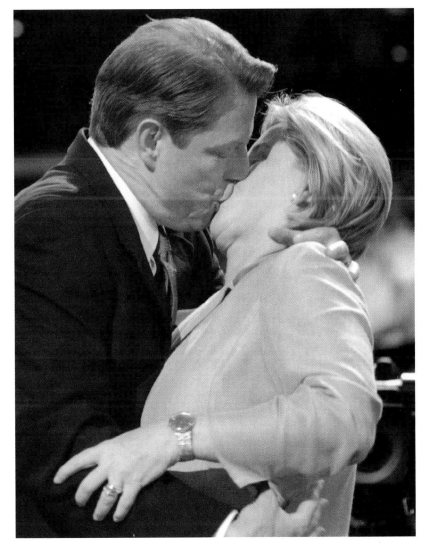

In protest against France's foreign policy, Al and Tipper Gore demonstrate the art of "freedom kissing."

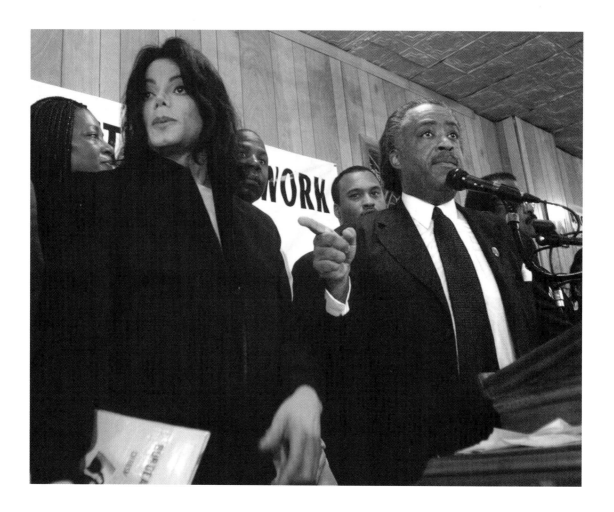

"Where else but in America could a poor black boy grow up to be a rich white ..."

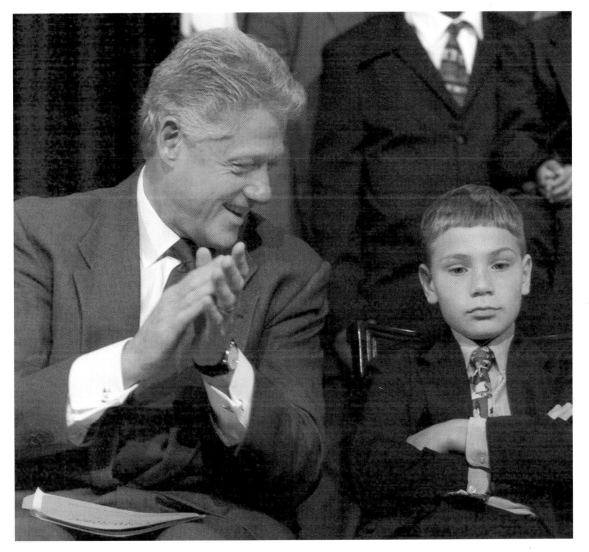

Former President Bill Clinton applauds the "courageous initiative of the one child who insists on his right to be left behind."

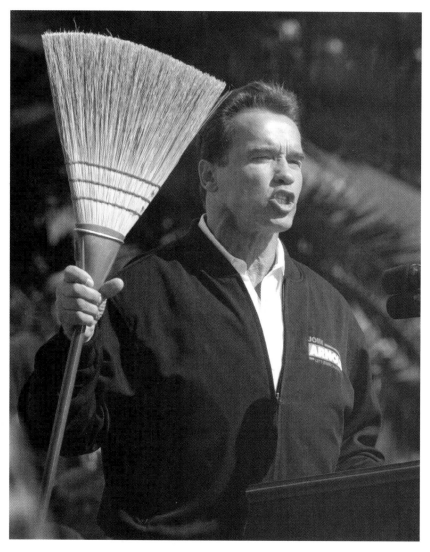

Candidate Arnold Schwartzenegger vows to repeal the unpopular "gas tax,"
while holding his wife Maria's favorite vehicle.

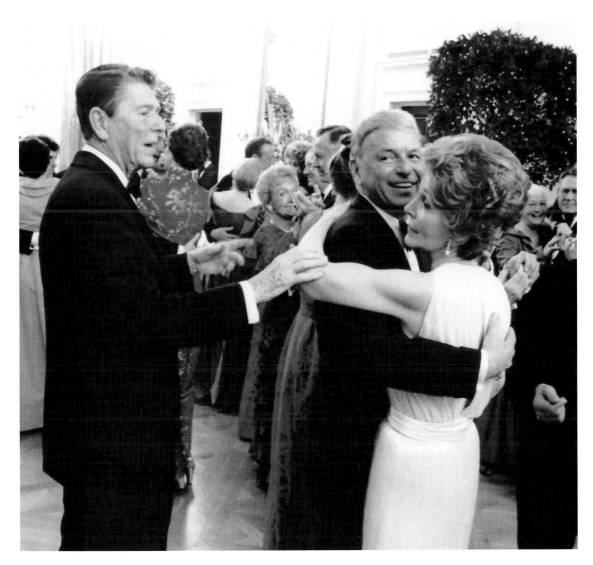

"I'm sorry Ronnie, you may be President, but Frank is
the Chairman of the Board."

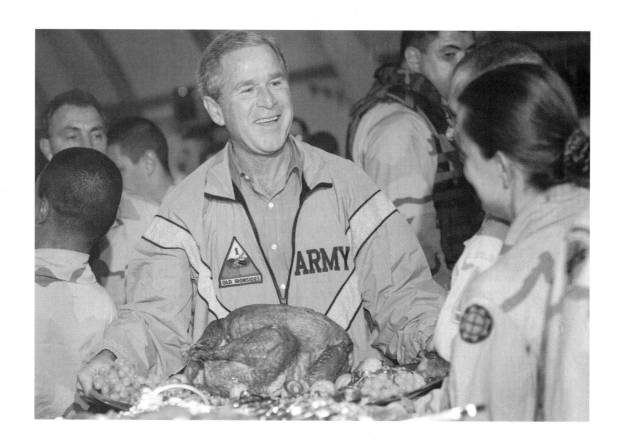

Can you pick the real turkey?

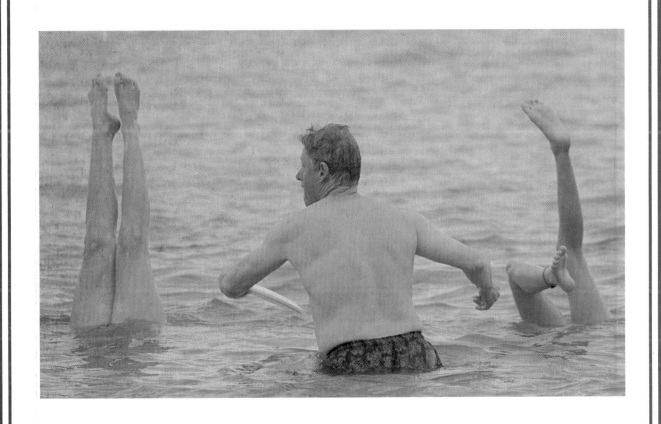

"Honest to God, Hillary, it was just me and a couple of my closest advisors on the Honolulu trip,"

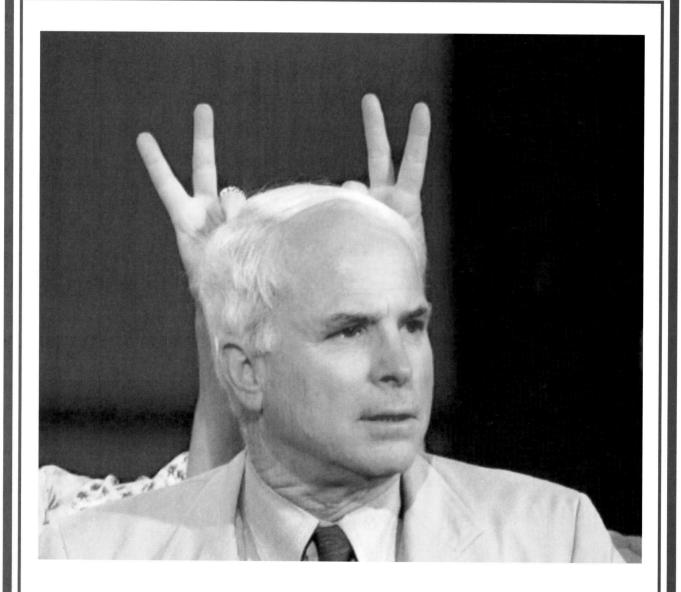

"No, why would you think that the religious right wishes me any ill?"

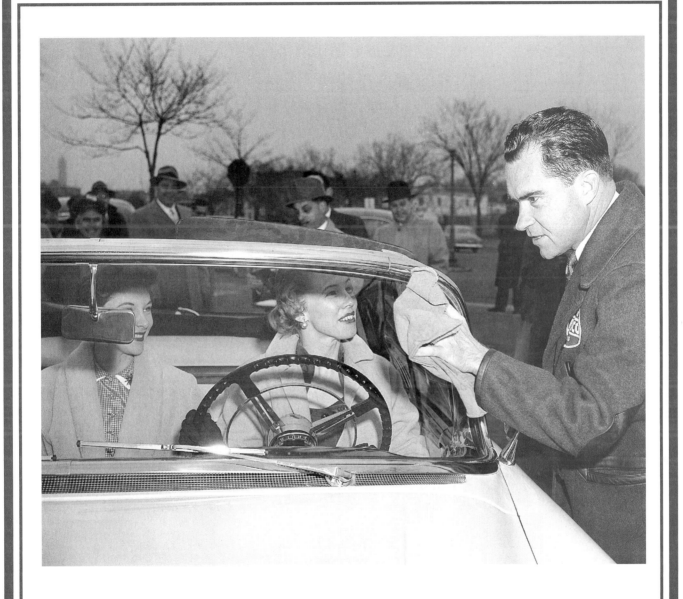

In the pre-squeegee law days, Nixon would do anything for a vote.

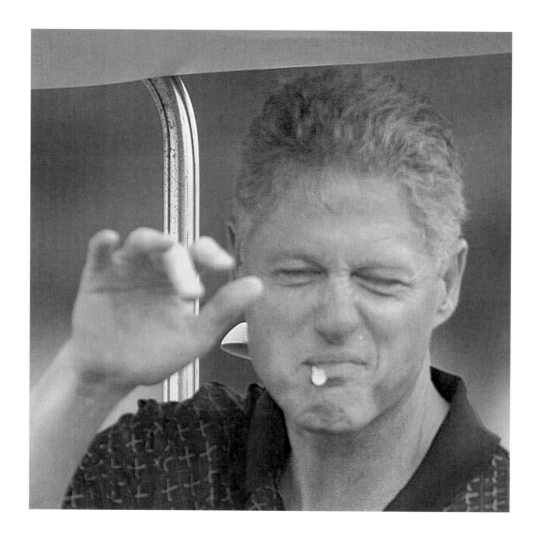

Close, but no cigar.

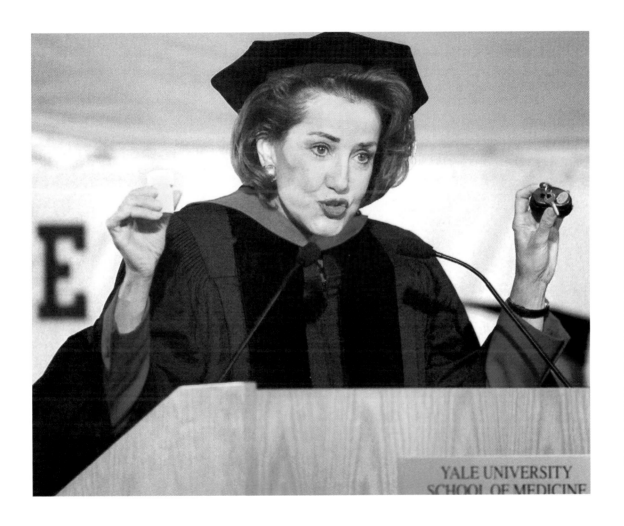

"Yes, Viagra *is* a miracle!."

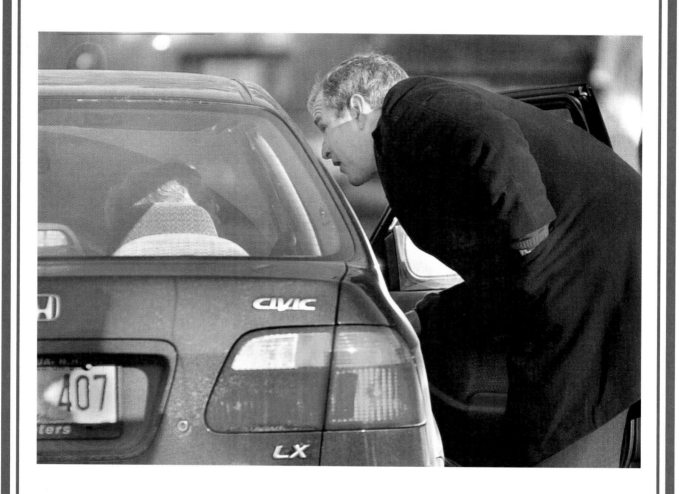

"Pleeze, won't you give me a ride. I really have to pee."

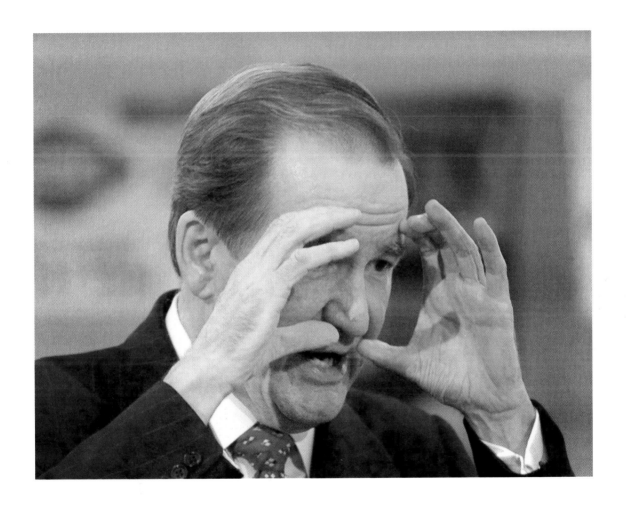

"Our goal is to make our minds smaller and smaller."

Life of the party.

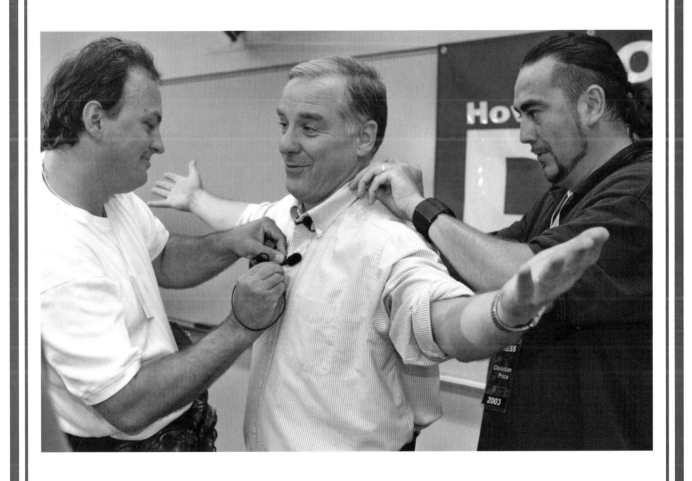

"Remember, if you so much as raise your voice—POW!!!
400,000 volts of electricity..."

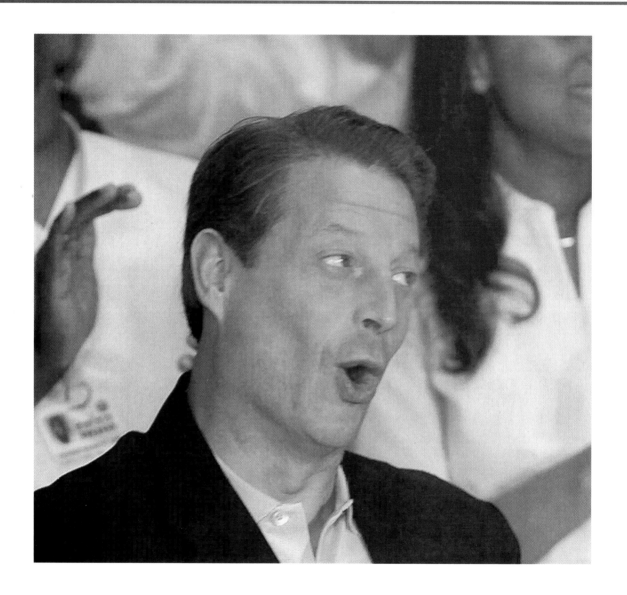

"Oh yes, we had a few puffs, back in the sixties."

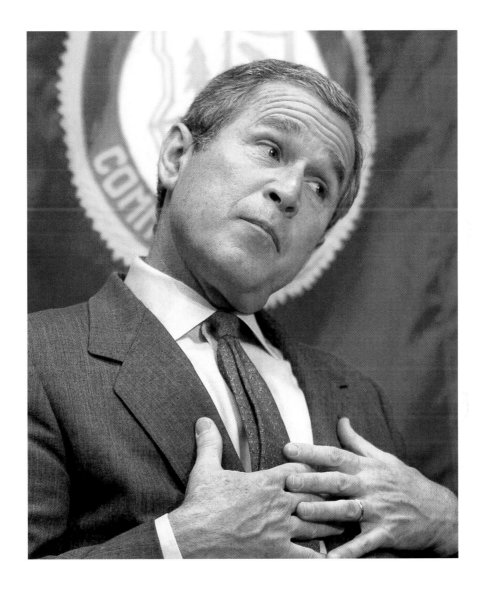

"It depends what you mean by 'drugs.'"

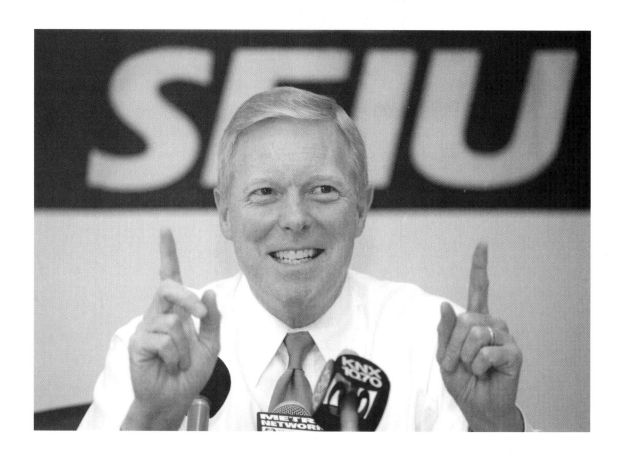

Gephardt makes a big point.

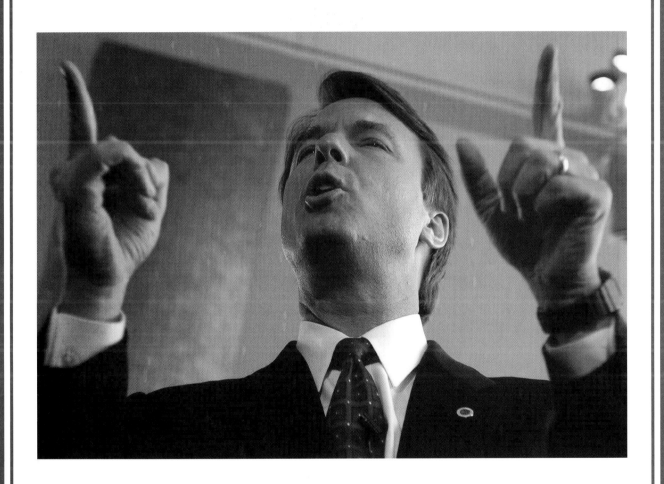

Edwards makes a bigger point.

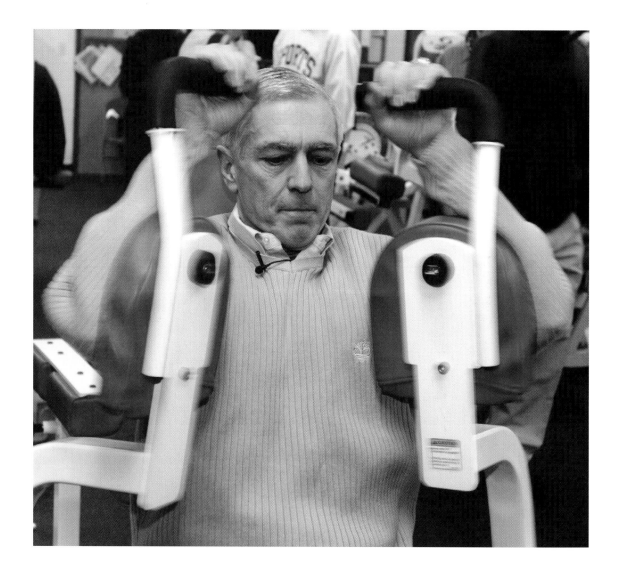

"If the Presidency doesn't pan out, I can always go on American Idol."

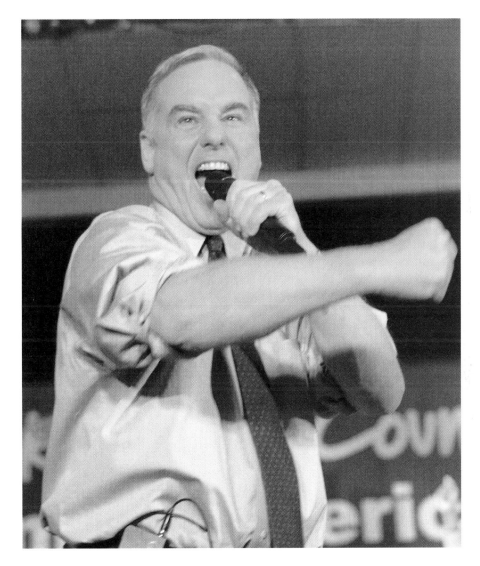

Geronimo!

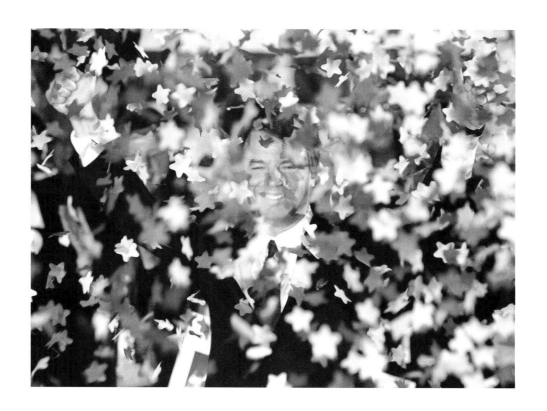

If only they were votes.

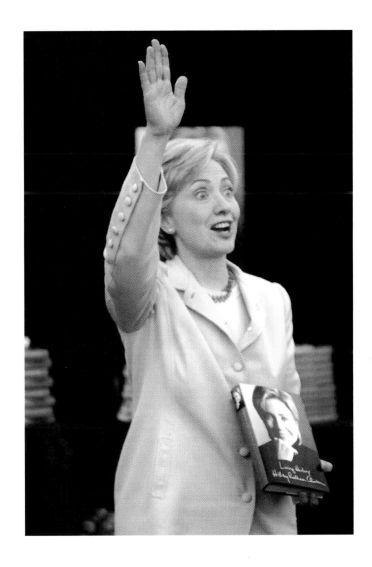

"Do I hear $1.75?"

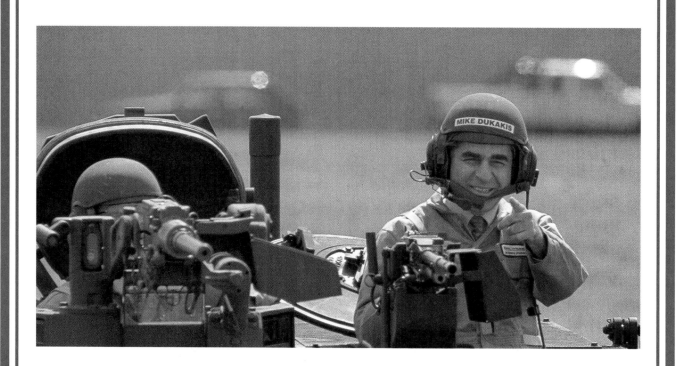

Snoopy for president.

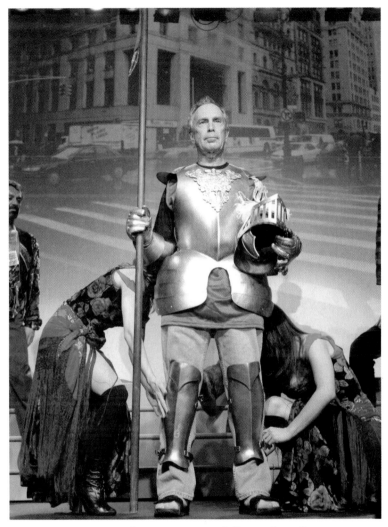

To run the unrunnable schools-
To rule the unrulable city-
To raise the unraisable tax-

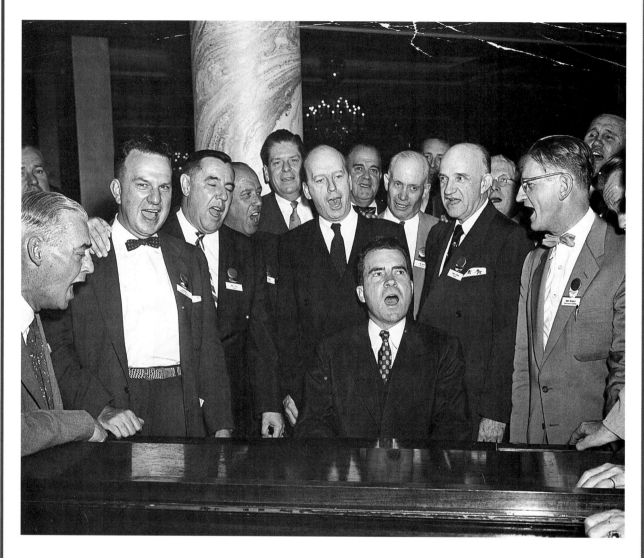

"For he's a jolly good felon,
For he's a jolly good felon..."

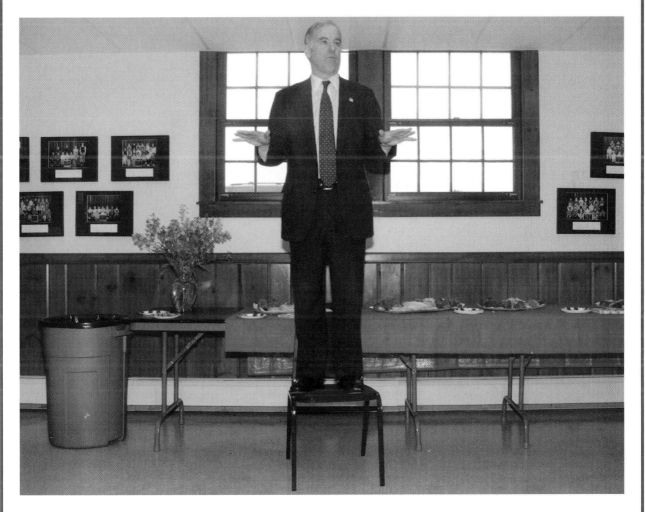

Addressing a "virtual audience," Dean expresses his thanks to Al Gore for inventing the internet.

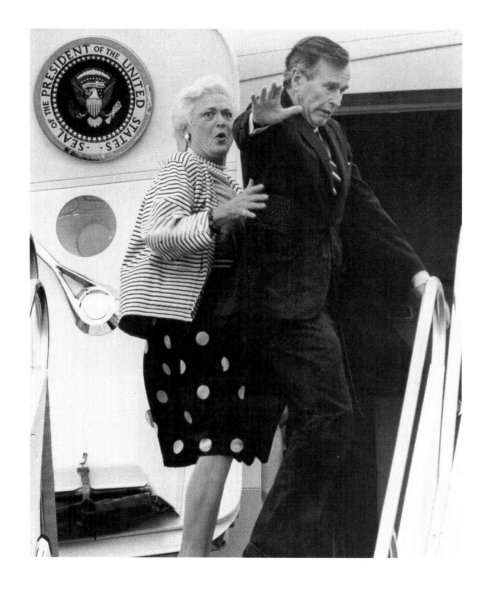

"Oh George, stop doing that Jerry Ford imitation again. It's not funny."

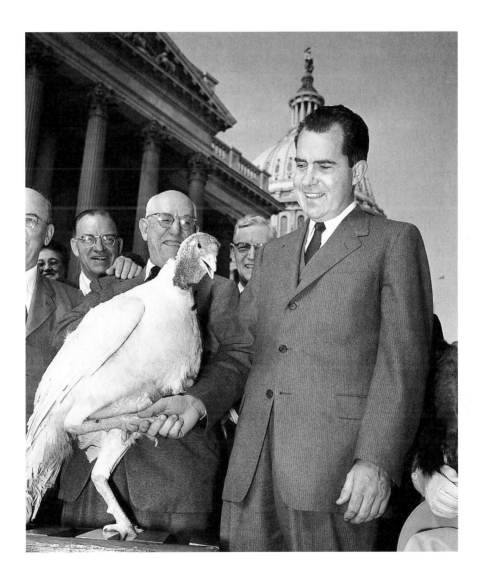

"I am <u>not</u> a cook."

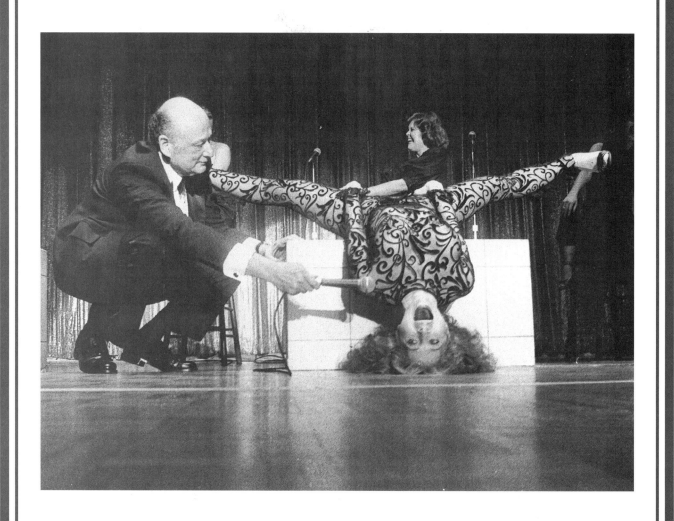

Ed Koch going after the split vote.

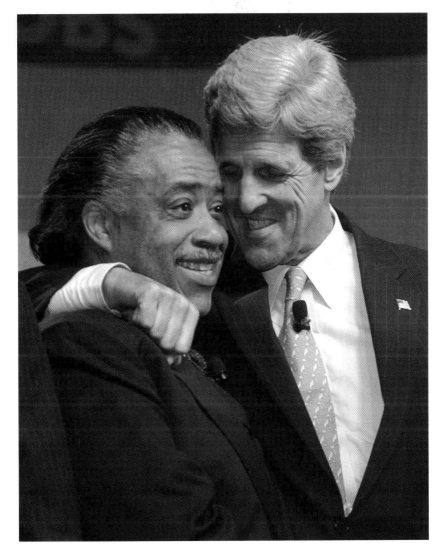

Kerry and Sharpton demonstrate their support of "gay marriage" by announcing their engagement.

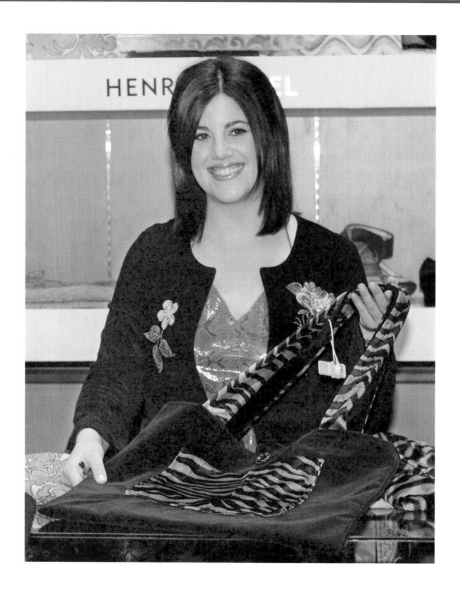

"And this fabric doesn't show any stains."

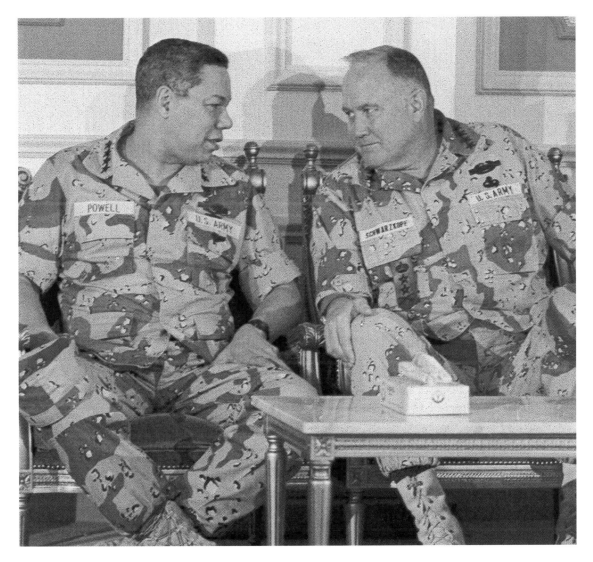

"I thought you said you were going to wear the khakis,
not the desert fatigues. Now look at us!"

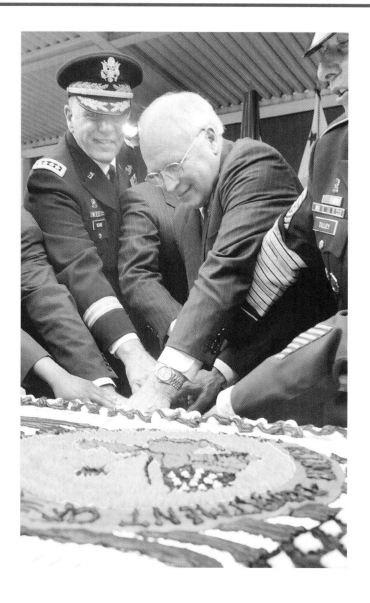

"First I'll eat half, then I'll eat the other half."

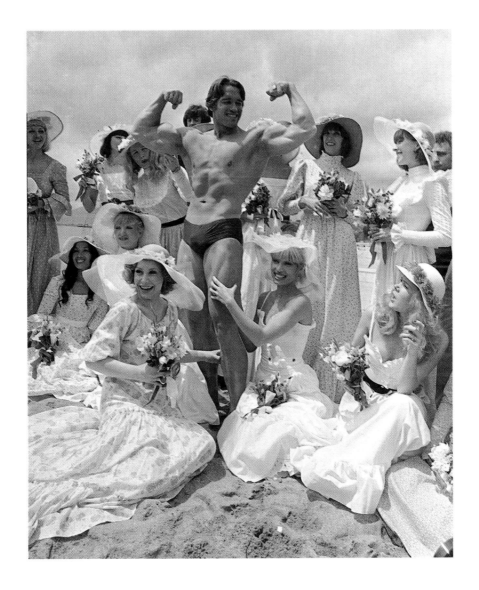

"Anyone for groping?"

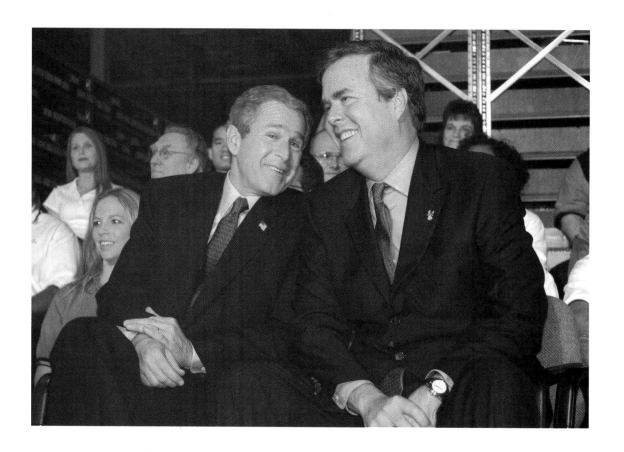

"And the best part was those old farts in Miami got so confused by the ballot that they voted for Buchanan!"

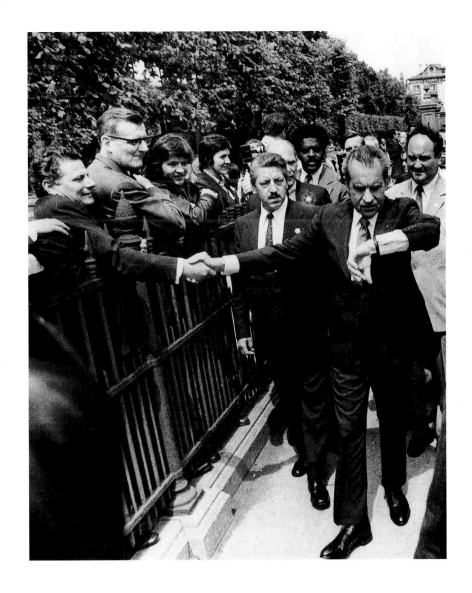

"Hi, nice to meet you. Hi, nice to meet you. Hi, nice to meet you..."

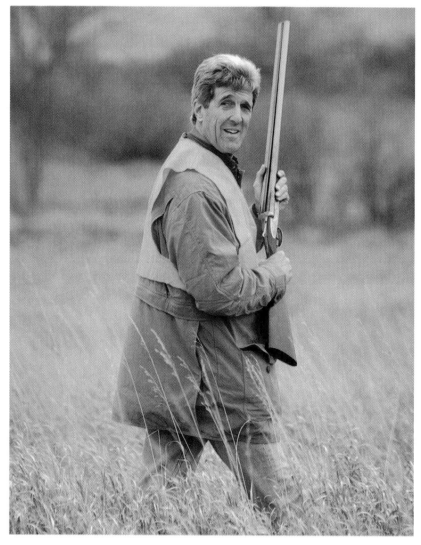

Sen. John Kerry hunts the wily gopher, unaware that his quarry is sleeping on the top of his head.

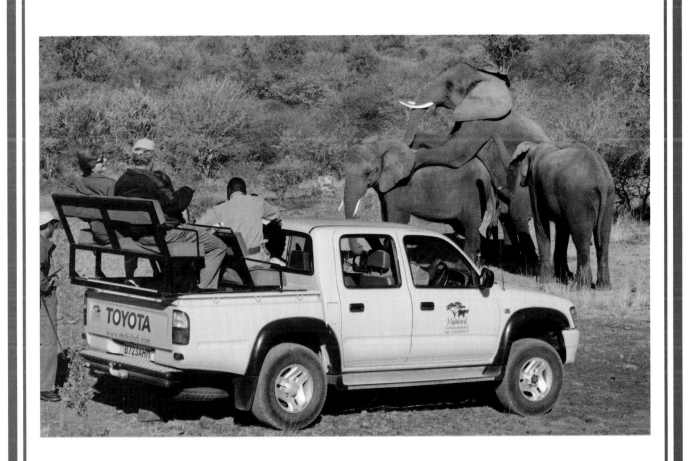

"Oh honey, look! It's Bill Clinton!"

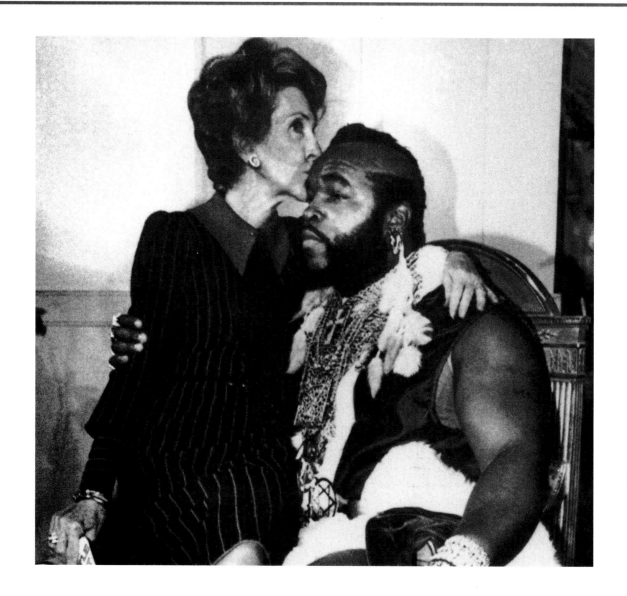

"Ronnie just doesn't understand me."

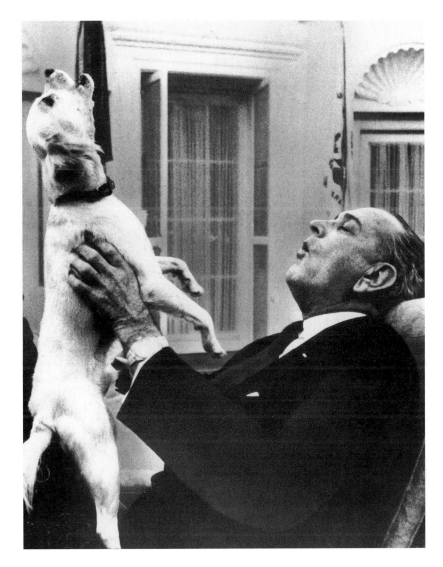

"The doggies howl,
deep in the heart of Texas."

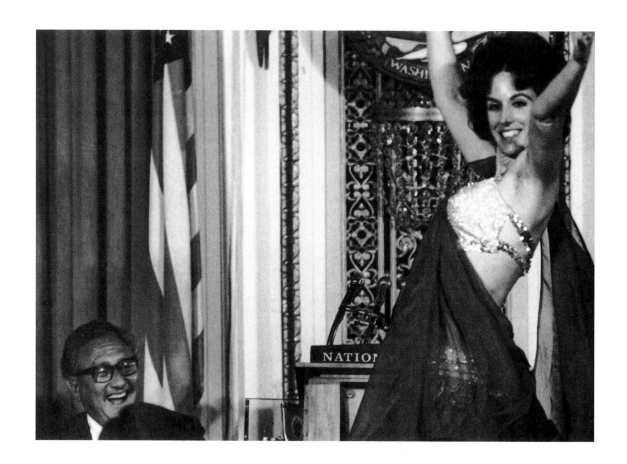

"I wonder who's Kissing-er now?"

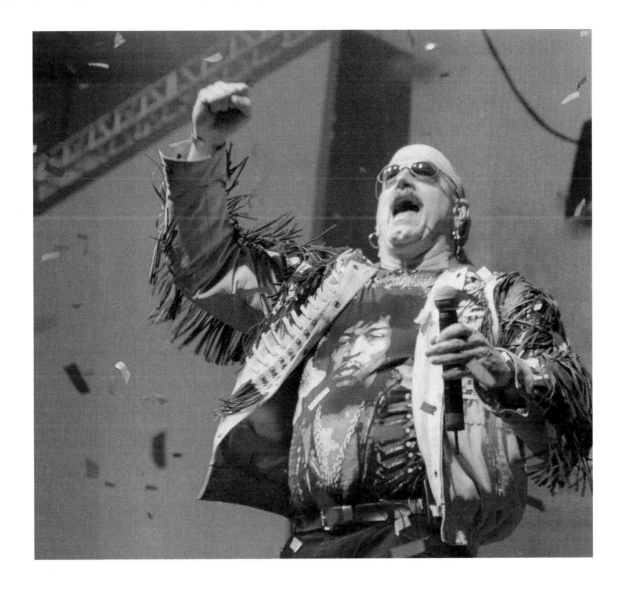

"I'm out of the Reform Party because Buchanan is just too wierd."

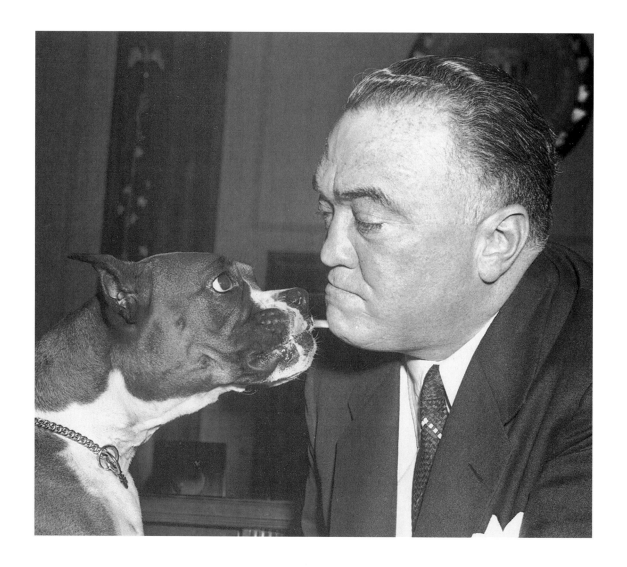

J. Edgar Hoover and his bitch.

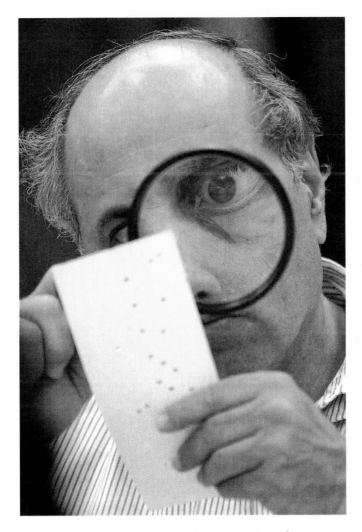

Bush or Gore... Gore or Bush...
Only the Chad knows and he won't tell.

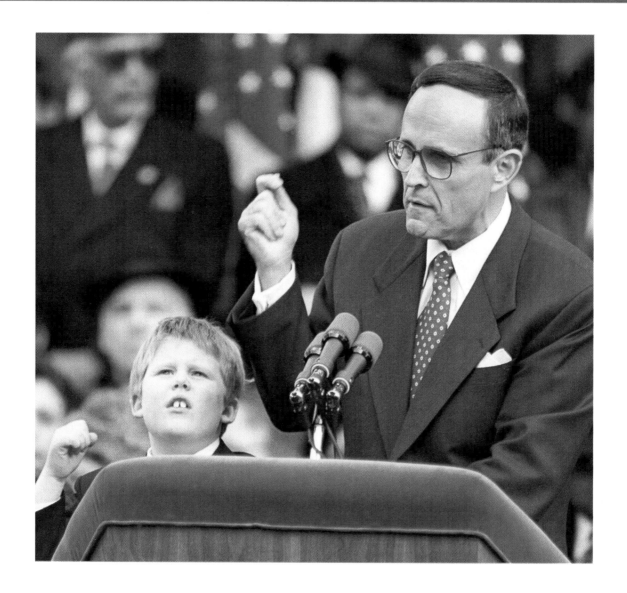

"Dad, follow my lead."

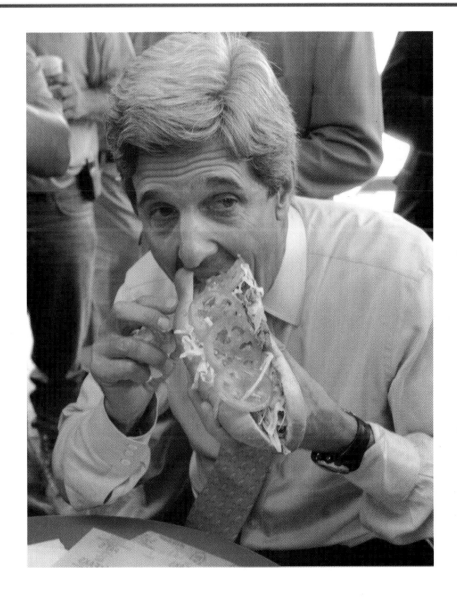

Courting the deli guy vote.

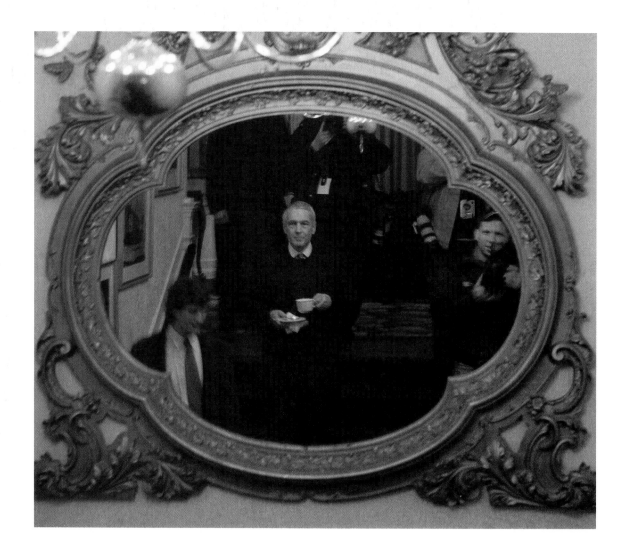

"Mirror, mirror, on the wall, who is the manliest candidate of all?"

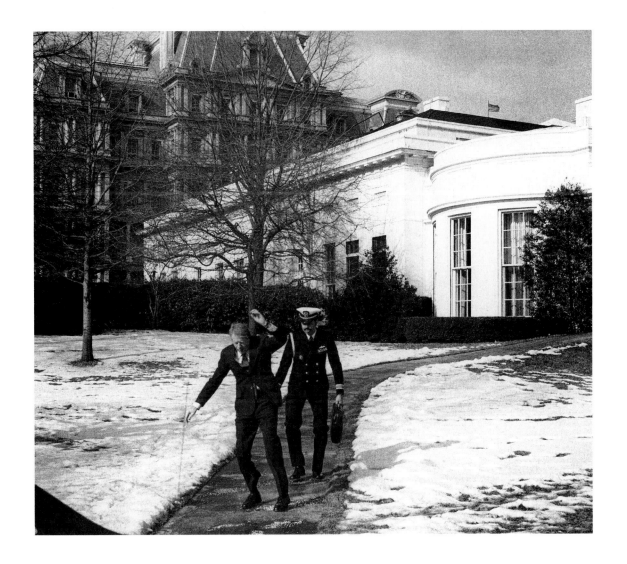

Jimmy Carter slipping away from the White House.

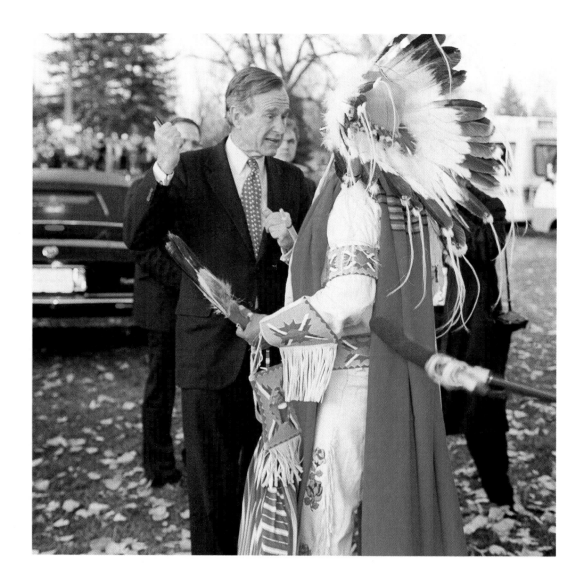

"No, no. Thanksgiving is at my house this year."

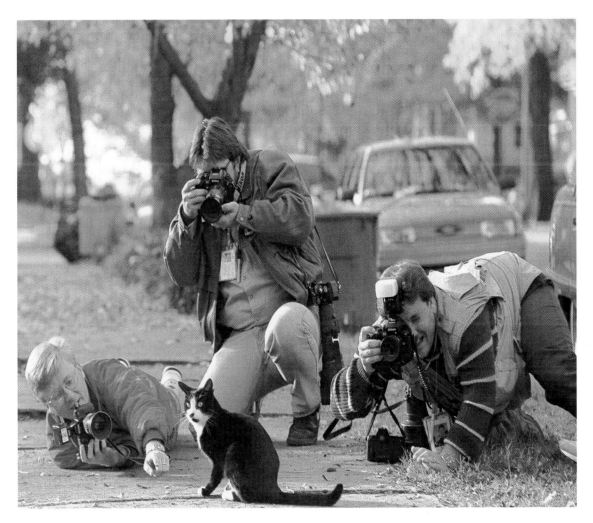

After eight years in the White House,
Socks learned to ignore the paparazzi.

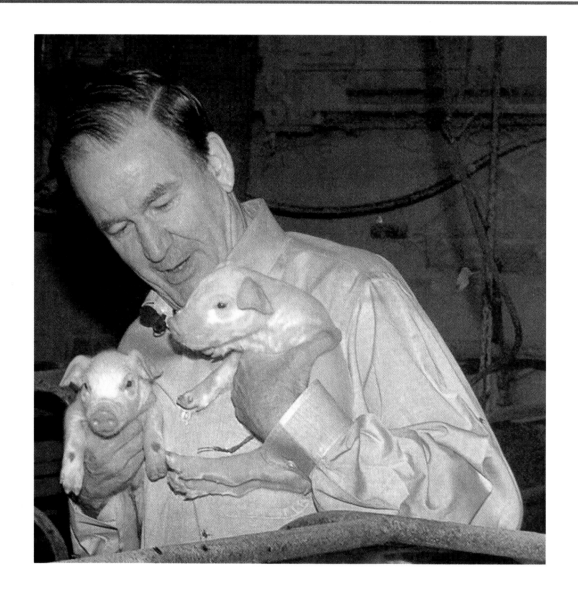

"Okay, let's poopoo on his shirt."

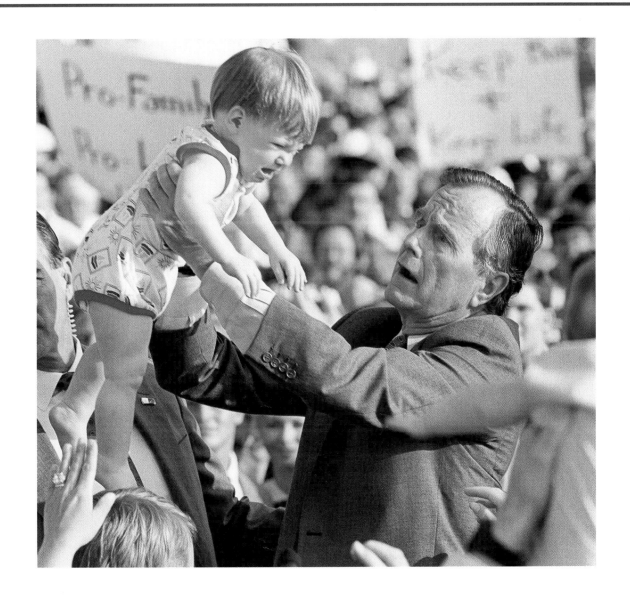

"I <u>am</u> kinder. I <u>am</u> gentler, dammit."

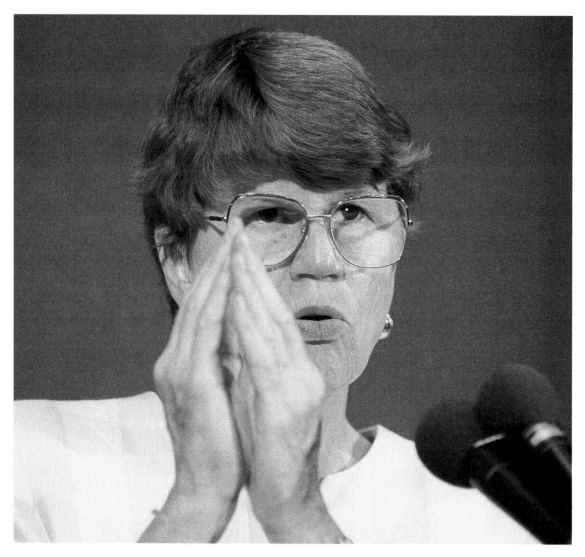

"This is the church, this is the steeple, open the door, send in the ATF troopers and firebomb the place."

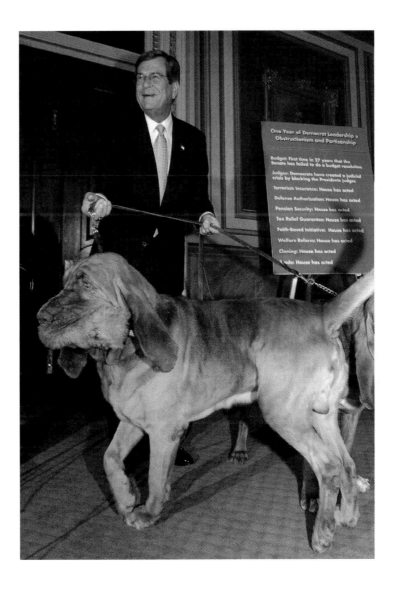

Dyslexic Senator Trent Lott attempts to bring God into government.

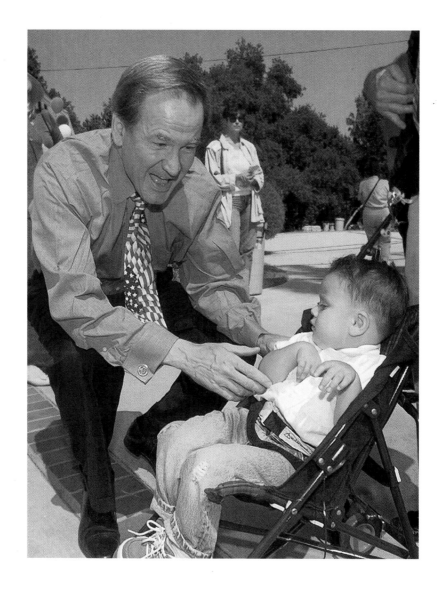

"Let's scare some kids."

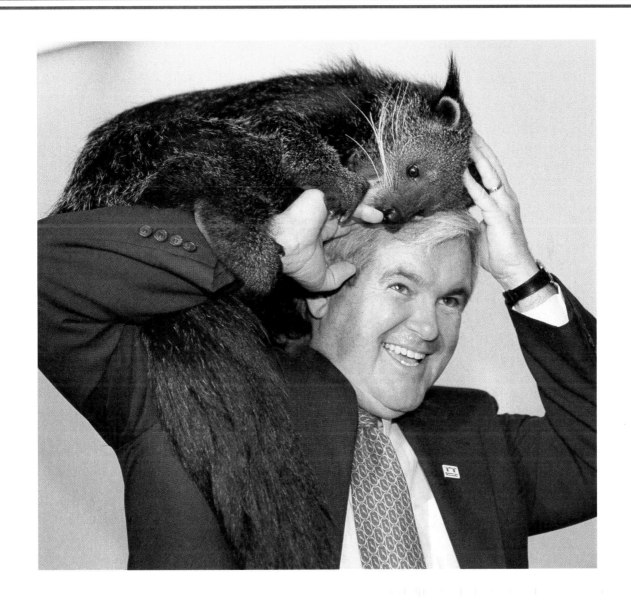

"I knew Davy Crocket, and you're no Davy Crockett."

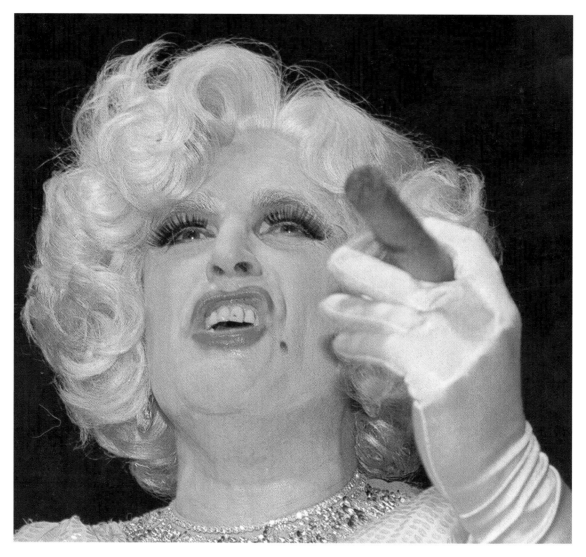

One of the many reasons that Giuliani had for
dropping out of the Senate race.

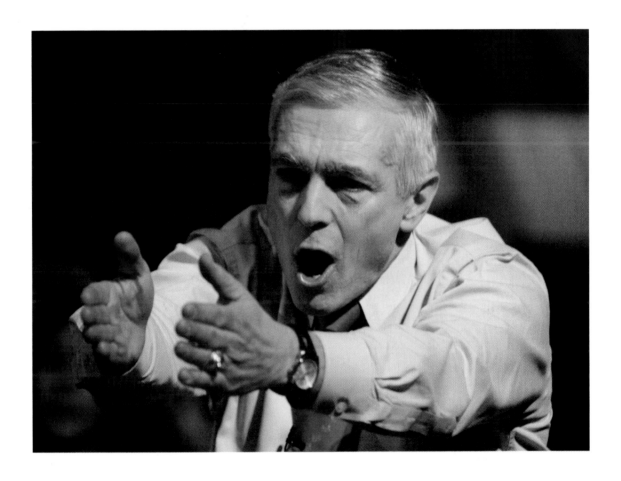

"And we're gonna go through the Republicans like
Patton went through Europe!"

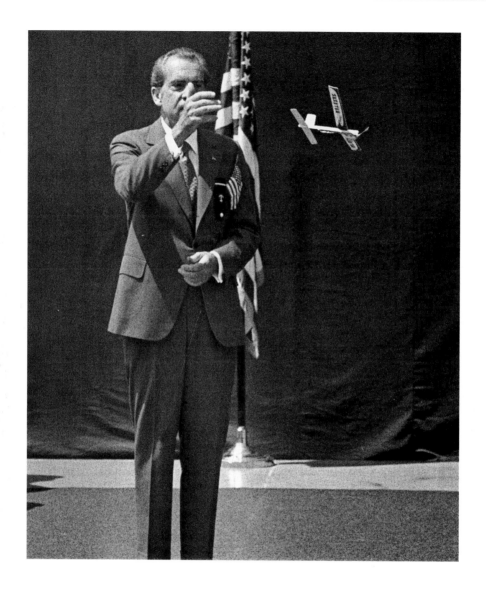

Nixon the aviator.

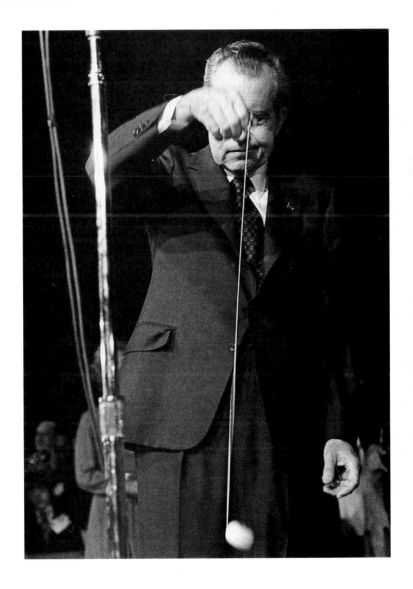

Nixon trying to get it up.

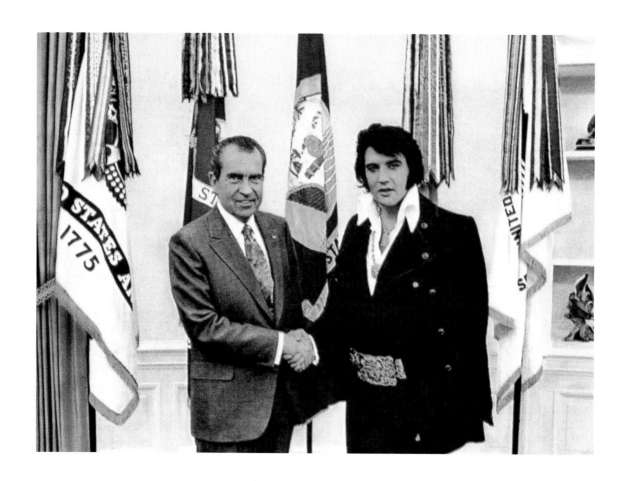

"So, you're the young fellow I saw on the Ed Sullivan Show, aren't you?"

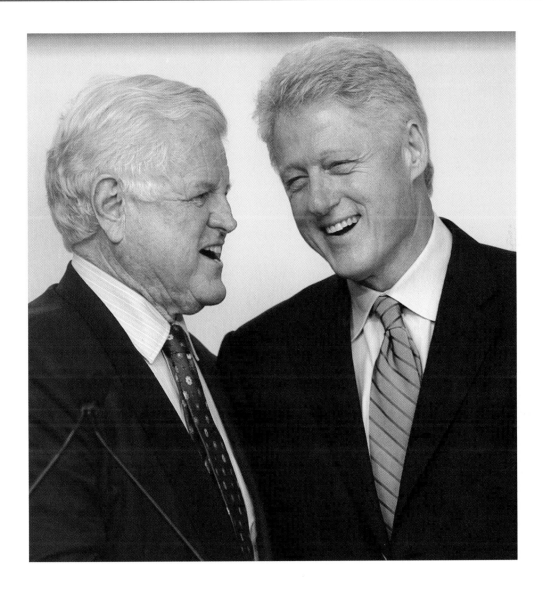

"OK, but I'll drive."

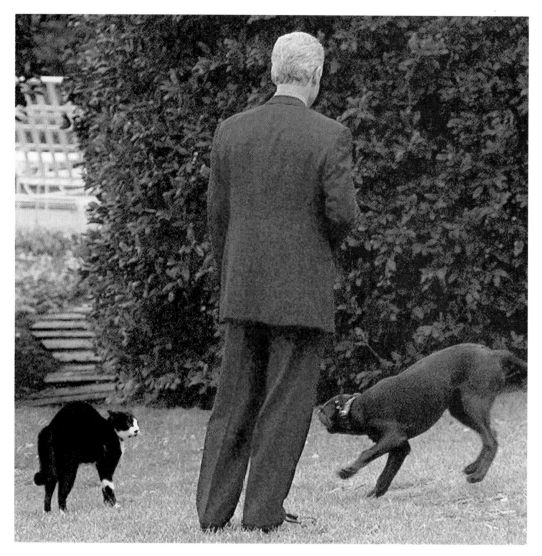

"Listen Buddy, Listen Socks, if I can't even get you guys
to get along, how am I going to deal with Congess?"

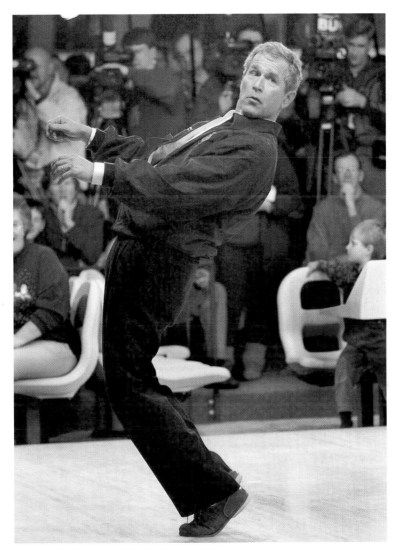

To get the nomination you lean to the right.
To win the election you lean to the left.

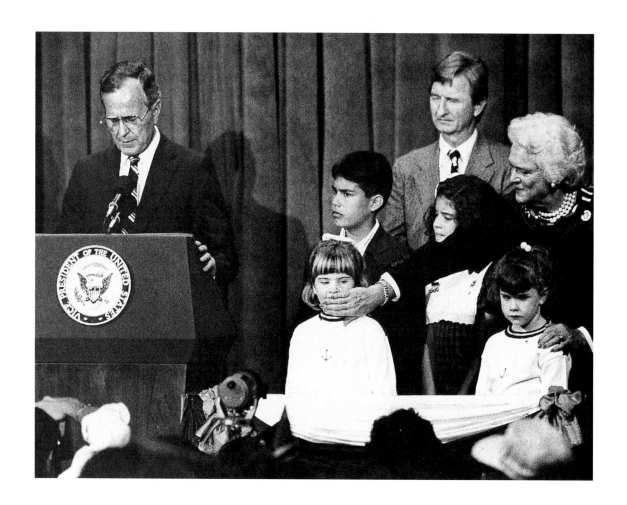

"No, no, no. Read <u>his</u> lips."

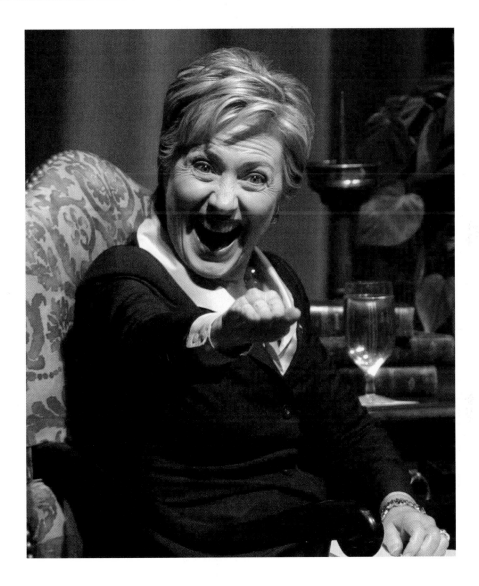

"Whazzup!"

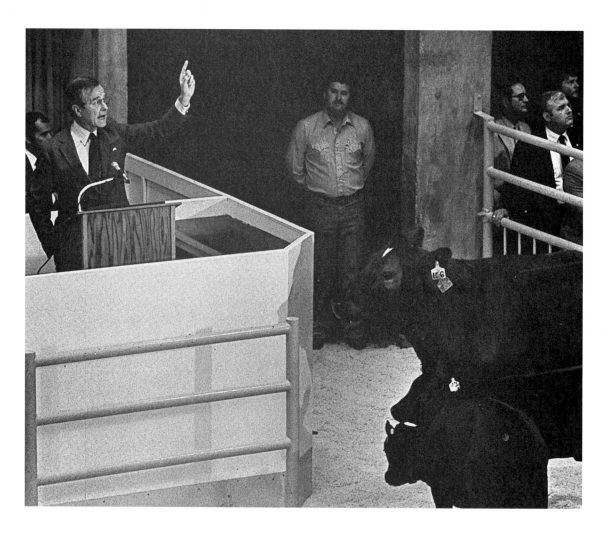

"I will stand by my position until the cows come home.
Whoops, gotta go."

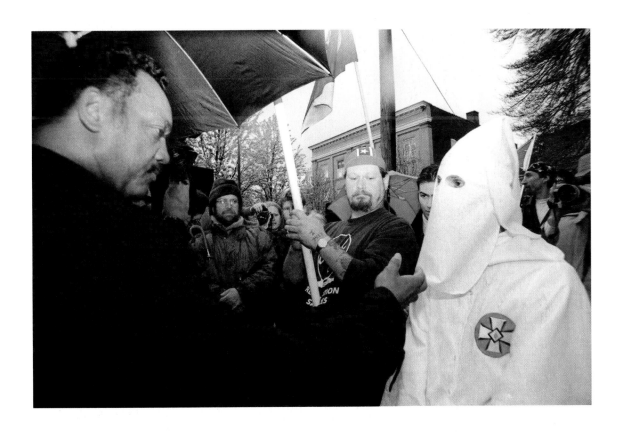

"Michael, this time you've gone too far! You're a disgrace
to the name of Jackson!"

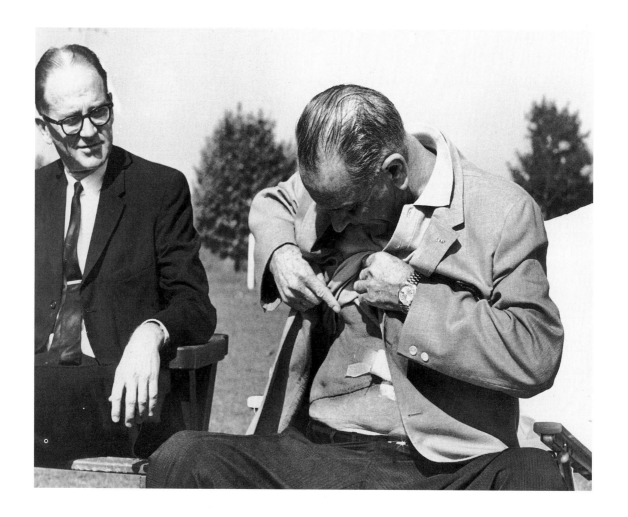

"And when Charlie comes down the Ho Chi Minh Trail here,
we'll nab him and kick him in the butt."

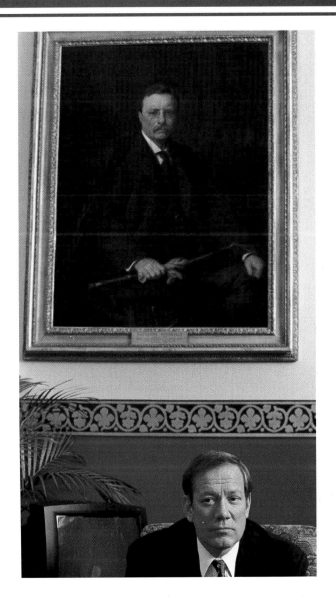

"I knew Theodore Roosevelt, and you, sir, are no Theodore Roosevelt."

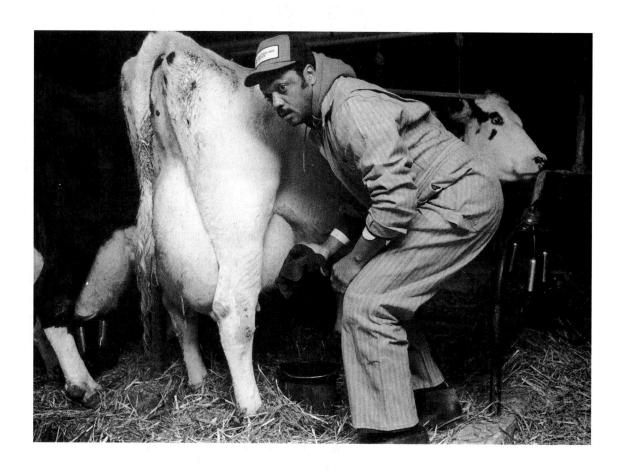

Jesse milking every opportunity.

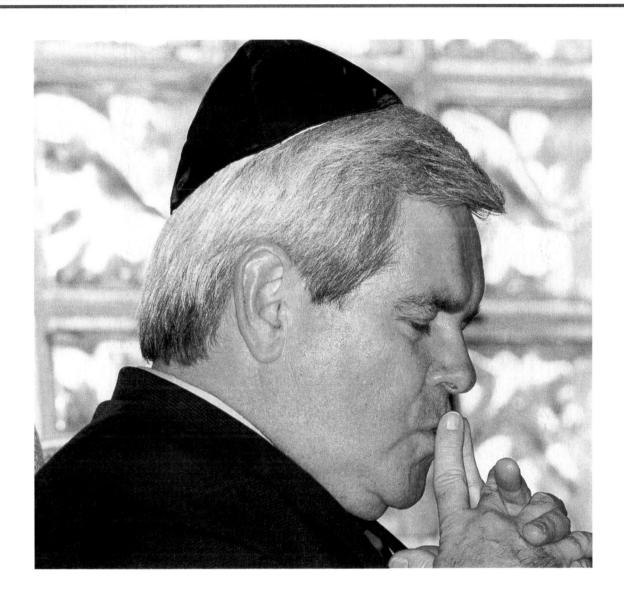

Rebbe Newt

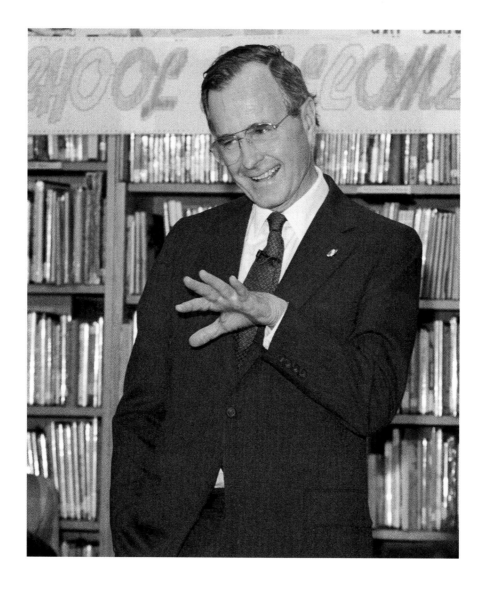

"No, when we were in the Navy, if they asked, we'd tell."

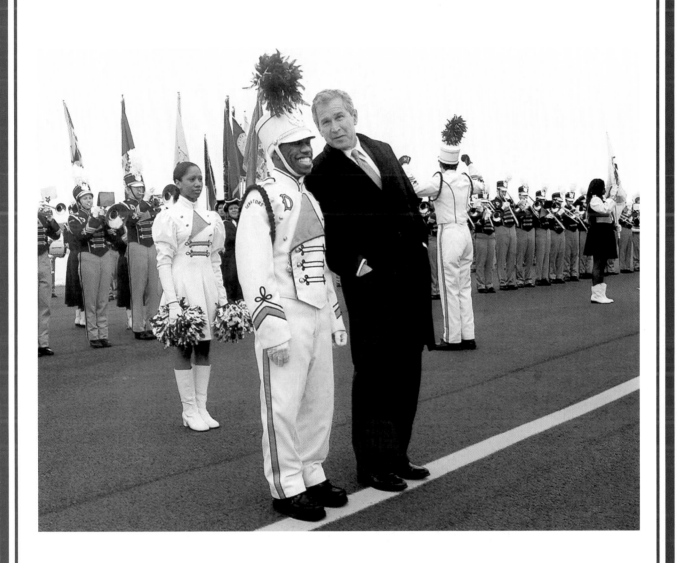

"Now that the Confederate flag is off the capitol building
in South Carolina, you'll vote for me. Won't you?"

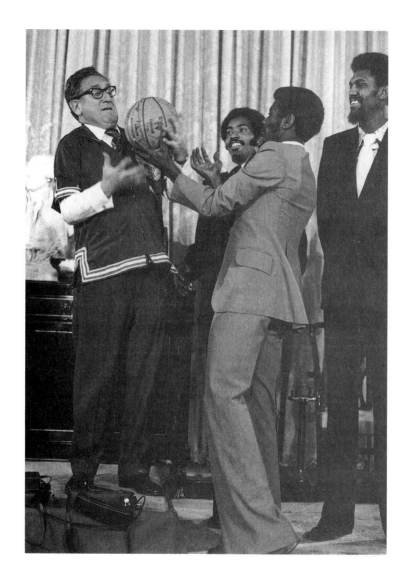

The Globetrotters meet another globetrotter.

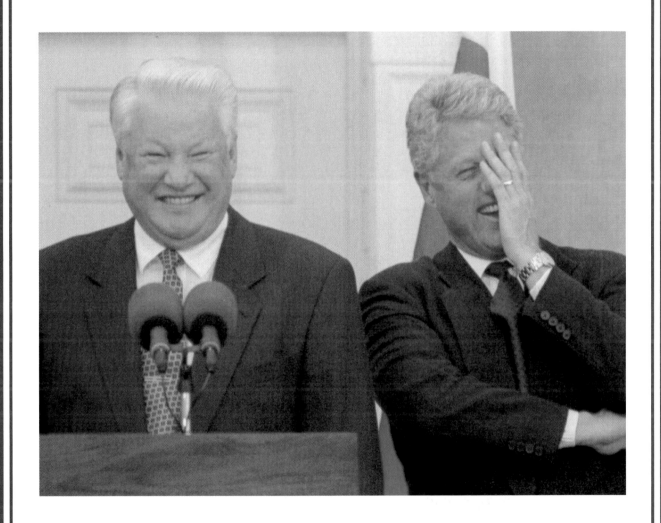

"And then there's the one about the Commissar and the Kremlin intern."

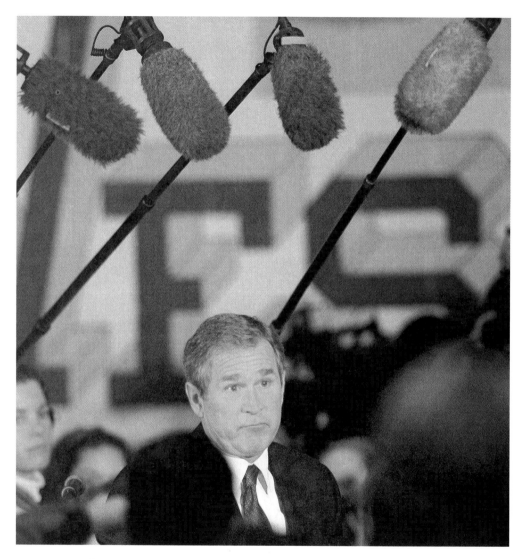

"Doberman Pinscher is the Chancellor of Germany.
Is that your final answer?"

"Now concentrate. True or false, Crepe Suzette is
the President of France?"

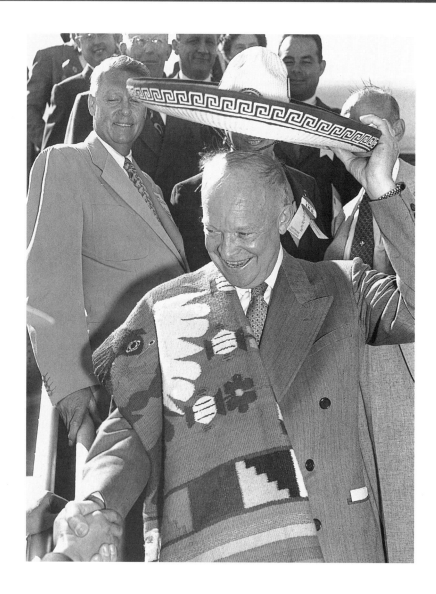

Me gusta Ike.

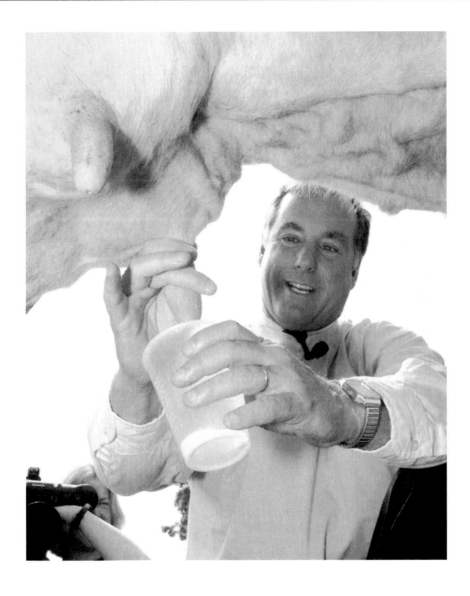

Why cows go mad.

PHOTO CREDITS AND CAPTIONS

PHOTO CREDITS

All photos from AP/Wide World except the following:

Page 5 Don Black, *Binghamton* (New York) *Sun & Press-Bulletin.* (Nelson Rockefeller)

Pages 17, 53, 74: White House Photo

Page 60: Bonnie Walker, *Philadelphia Inquirer*

Page 75: James Shepley, Time Inc.

Page 80: Jim Curley, *Columbia* (Missouri) *Tribune*

THE REAL CAPTIONS

Page 4. President Bush picks up his dog, Barney, as they board Air Force One in Waco, Aug. 30, 2003 for the return trip to Washington at the conclusion of their Texas vacation.

Page 5. (top to bottom) Former President Ronald Reagan tries on a USC Trojan helmet during ceremonies in Los Angeles welcoming him home from Washington in 1989.

New York Governor Nelson Rockefeller models a stockman's hat—presented to him in 1959 by a Dallas banker—that turned out to be too large.

Page 6. (left to right) Republican presidential candidate George W. Bush returns a crying child to his mother during a campaign stop in Tacoma, WA.

Pres. Ronald Reagan shakes the trunk of an 18-month-old Asiatic elephant on the South Lawn of the White House in 1984.

Page 7. (left to right) Ronald Reagan has trouble holding his dog, Victory, on a flight during his first presidential campaign in 1980.

Democratic presidential hopeful Bill Bradley snags a "flying fish" at Seattle's landmark Pike Place Fish Co. during a campaign stop.

Page 8. (top to bottom) President Calvin Coolidge wears Sioux tribal headdress during ceremonies in South Dakota in 1927.

New York Mayor Rudolph Giuliani, wearing a costume from *Grease,* sits astride a motorcycle at a press dinner in 1996.

President Franklin Delano Roosevelt wears an Indian headdress as he participates in Boy Scout camp in New York in 1933.

Page 9. (top to bottom) President Ronald Reagan gives photographers the ear wiggle at a photographer's dinner in Washington in 1986.

Vice President Nelson Rockefeller gives the finger to hecklers in Binghamton, NY, during a political appearance in 1976.

Page 11. Hillary Clinton struggles with a microphone cord before a television interview in Washington in 1995

Page 12. Gov. George Bush of Texas flips flap-jacks during a pancake flipping contest in Manchester, NH, in 2000.

Page 13. Vice President Al Gore kisses his wife, Tipper, as he steps onto the stage at the Democratic National Convention in Los Angeles, CA, August 17, 2000.

Page 14: Michael Jackson and Rev. Al Sharpton at Sharpton's National Action Network headquarters, New York, July 9, 2002.

Page 15. President Bill Clinton applauds during an adoption event in Washington, DC, in 1999. Seated with him is Brian Keane, 11, an adoptee.

Page 16. Arnold Schwarzenegger, Republican candidate for governor of California, holds a broom vowing to sweep Governor Gray Davis out of office as he campaigned in Sacramento, CA, October 5, 2003.

Page 17. President Ronald Reagan cuts in on Frank Sinatra as the singer dances with First Lady Nancy Reagan at a White House party in 1981.

Page 18: President Bush holds up a turkey platter for U.S. troops at Baghdad International Airport, Nov. 27, 2003

Page 19. President Bill Clinton flips a frisbee as swimmers do hand stands in the ocean at Hawaii in 1993.

Page 20. Sen. John McCain inspects the podium as a staff member has a laugh at the senator's expense in San Diego in 1996.

Page 21. Vice President Nixon wipes a windshield as part of a March of Dimes fund-raising effort in Washington in 1955.

Page 22. President Clinton shows how close he was to a successful putt during a golf match in Massachusetts in 1997.

Page 23. Elizabeth Dole holds a gun lock and aspirin in her hands as she addresses the Yale School of Medicine in Connecticut in 1999.

Page 24. Presidential candidate George W. Bush greets voters at a parking lot in Bedford, NH in 2000.

Page 25. Presidential hopeful Pat Buchanan addresses students at Lutheran North High School in Michigan in 1999.

Page 26. Former President George Bush makes rabbit ears behind Barbara Bush during dedication ceremonies of The Ford Library and Museum in Michigan in 1997.

Page 27. Democratic presidential hopeful Howard Dean has microphones attached to his shirt for a news conference in Norman, Okla., Saturday, Oct 4, 2003.

Page 28. Presidential candidate Al Gore has a laugh prior to a healthcare discussion in Florida in 2000.

Page 29. Presidential candidate George W. Bush answers a question during a forum in Washington State in 2000.

Page 30. Presidential candidate Rep. Richard Gephardt, D-Mo., at the headquarters of the Service Employees International Union in Los Angeles, June 18, 2003.

Page 31. United States Senator and Democratic Presidential hopeful John Edwards holds a town meeting in Hanover, New Hampshire, 22 January 2004, at Dartmouth College.

Pages 32. U.S. Democratic presidential candidate retired General Wesley Clark tries out some of the exercise equipment at the Seacost family YMCA in Portsmouth, New Hampshire, January 16, 2004.

Page 33. Democratic presidential hopeful Howard Dean yells "YEAH!" while addressing supporters during his caucus night party in West Des Moines, Iowa, January 19, 2004.

Page 34. Democratic presidential candidate, North Carolina Senator John Edwards, is showered in confetti at his caucus party at a hotel in Des Moines, January 19, 2004.

Page 35. Senator Hillary Rodham Clinton holds a copy of her book *Living History* as she greets autograph seekers in Fairfax, VA, June 11, 2003.

Page 36. Presidential candidate Michael Dukakis wears a tank driver's helmet as he rides in a battle tank in Michigan in 1988.

Page 37. New York Mayor Michael Bloomberg wears armor, for his role as "Mayor of La Mancha" in an annual New York media production spoofing both politicians and media, April 12, 2003.

Page. 38. Vice President Richard Nixon leads an after dinner songfest with Republican politicos in Washington, DC, in 1955.

Page 39. Governor Howard Dean, campaigning for the Democratic presidential nomination, stands on a chair as he addresses supporters in Sugar Hill, NH, May 25, 2003.

Page 40. First Lady Barbara Bush reacts as President George Bush steps on her foot while boarding Air Force One at Andrews Air Force Base in 1989.

Page 41. Vice President Richard Nixon shakes hands with a turkey destined for the table of President Dwight Eisenhower. The turkey presentation, this one in 1955, is an annual White House event.

Page 42. Mayor Edward Koch of New York City interviews Anita Morris during a performance in 1983.

Page 43. Senator John Kerry gives Reverend Al Sharpton a hug after both participated in the AFL-CIO presidential forum in Chicago, IL, August 5, 2000.

Page 44. Monica Lewinsky shows off one of the handbags from her Spring collection at a New York City department store in 2000.

Page 45. Chairman of the Joint Chiefs of Staff Colin Powell confers with Gen. H. Norman Schwarzkopf in Saudi Arabia in 1991.

Page 46. Vice President Dick Cheney cuts an Army birthday cake at the Pentagon, June 13, 2003, as they celebrated the Army's 228 years of service to the country.

Page 47. Arnold Schwarzenegger strikes a pose for a beach audience in Cannes, France, May 20, 1977, where the documentary film *Pumping Iron* was being presented.

Page 48. President George W. Bush and Florida Governor Jeb Bush share a moment at America II Electronics in St. Petersburg, FL, March 8, 2002.

Page 49. President Richard Nixon checks his watch while shaking hands in Brussels in 1974.

Page 50. Democratic presidential hopeful Senator John Kerry hunts pheasants near Colo, IA, October 31, 2003.

Page 51. President George W. Bush, with First Lady Laura Bush and daughter Barbara, watches African elephants during a drive through Mokolodi Nature Reserve near Gaborone, Botswana 10 July 2003.

Page 52. First Lady Nancy Reagan sits on the knee of TV personality Mr. T during a tour of the White House Christmas décor in 1983.

Page 53. President Lyndon Johnson and his dog, Yuki, share howls at a White House sing along in 1971.

Page 54. Secretary of State Henry Kissinger enjoys a belly dancer's performance at a birthday celebration in Washington's National Press Club in 1977.

Page 55. Minnesota Gov. Jesse Ventura yells to the crowd at an Inauguration Ball in Minnesota. Ventura wore pink sunglasses, three earrings, a leather jacket and a bandana.

Page 56. FBI director J. Edgar Hoover poses with dog show entrant, Holly Spring, in Hoover's Washington, DC, office in 1954.

Page 57. Broward County canvassing board member Judge Richard Rosenberg checks a disputed ballot, in Fort Lauderdale, FL, Nov. 24, 2000.

Page 58. Andrew Giuliani gestures while his father, newly elected New York Mayor Rudolph Giuliani, speaks at his inauguration in New York City in 1994.

Page 59. Sen. John Kerry, bites into a Philly cheese steak sandwich during a campaign stop in South Philadelphia, Aug 11, 2003.

Page 60. General Wesley Clark, Ret., is reflected in a mirror in Dixville Notch as he awaits the results of the midnight primary voting there, 27 January 2004.

Page 61. President Jimmy Carter slips on ice (but doesn't fall) outside The White House in 1977.

Page 62. President George Bush with Crowe Indians in Montana in 1992 during a campaign stop.

Page 63. Photographers surround White House cat Socks during the cat's stroll on the White House grounds.

Page 65. President George Bush holds a baby as he greets supporters at a Georgia campaign stop in 1992.

Page 66. Attorney General Janet Reno responds to questions at a National Press Club luncheon in Washington, DC, in 1993.

Page 67. During a Washington, DC, news conference in which he accused Democrats of obstructing legislative progress, Senator Trent Lott uses a bloodhound to help "find" legislation, May 22, 2002.

Page 68. Presidential hopeful Pat Buchanan attempts to make a child laugh during a campaign fundraiser in California in 1999.

Page 69. House Speaker Newt Gingrich "wears" a Binturong bearcat as a hat in his Washington, DC, office. Several animals were in the office with zoo officials from Columbus, Ohio.

Page 70. Mayor Rudolph Giuliani is dressed in drag for an appearance before the New York Press Club in 1997.

Page 71. U.S. Democratic presidential candidate, retired General Wesley Clark, speaks to a crowd supporters at a rally in Portsmouth, New Hampshire January 24, 2004.

Page 72. President Richard Nixon flies a toy airplane presented to him by the graduating class of the US Naval Academy in 1974.

Page 73. President Richard Nixon struggles with a yo-yo given to him at a performance at the Grand Ol' Opry in 1974 in Tennessee.

Page 74. President Nixon shakes hands with Elvis Presley in the White House in 1970.

Page 75. U.S. Sen. Edward M. Kennedy, D-Mass., and former President Bill Clinton laugh together as Kennedy introduces Clinton at the John F. Kennedy Library in Boston, Wednesday, May 28,2003.

Page 76. Socks and Buddy, White House cat and dog, have a troubled first meeting outside the Oval Office in 1998. President Bill Clinton mediates.

Page 77. Presidential candidate George W. Bush puts body English into his follow through during candlepin bowling in New Hampshire in 2000.

Page 78. President elect George Bush delivers an acceptance speech in Houston in 1988. Wife Barbara covers up the mouth of their yawning granddaughter (also named Barbara).

Page 79. Former first lady and Sen. Hillary Rodham Clinton, D-N.Y., waves to someone during the women and politics forum at The Peace Center for the Performing Arts, Monday, Oct. 6, 2003 in Greenville, SC.

Page 80. Vice President George Bush campaigns at the University of Missouri in 1984, where he drew some 400 students and three bovine listeners.

Page 81. Reverend Jesse Jackson tries to lift the hood of a Ku Klux Klan (KKK) protestor in Wallingford, CT, April 26, 2000. The KKK protested the closing of government offices on Martin Luther King Day.

Page 82. Asked about his recovery from a gall bladder operation, President Lyndon Johnson pulls up his shirt and shows his scar at his ranch in 1965.

Page 83. New York Gov. George Pataki sits under a portrait of President Theodore Roosevelt during a 1998 interview in Pataki's office.

Page 84. Jesse Jackson prepares a cow for milking in Iowa in 1987 prior to the Iowa caucuses.

Page 85. House Speaker Newt Gingrich gathers his thoughts before speaking to a synagogue congregation in Georgia in 1995.

Page 86. Vice President George Bush talks to schoolchildren in New York City during his campaign in 1988.

Page 87. Presidential hopeful George W. Bush stands with bandleader Michael Brown during a campaign stop at a high school in Delaware in 2000.

Page 88. The Harlem Globetrotters toss a ball to Secretary of State Henry Kissinger during a Washington visit in 1978.

Page 89. President Bill Clinton laughs at a comment Russian President Boris Yeltsin made to journalists at a press conference in New York in 1995.

Page 90. Boom microphones hover over George Bush as he meets with a crowd during a campaign visit to Ohio in 2000.

Page 91. Presidential hopeful George W. Bush prepares to roll his bowling ball during a candlepin game in New Hampshire in 2000.

Page 92. Presidential nominee Dwight Eisenhower tries on Mexican dress prior to a political speech in California in 1952.

Page 93. Governor Howard Dean tries his hand at milking during a Dairy Day activity in Montpelier, VT, June 1, 2000.